Flowers & Leaves

Denise Westcott Taylor

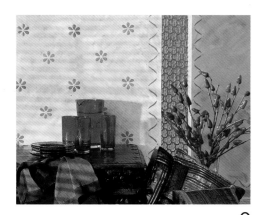

Indian Blooms _____ 8

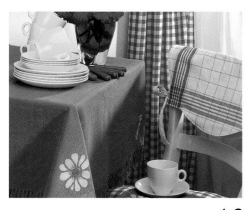

Sunshine Daisies _____ 12

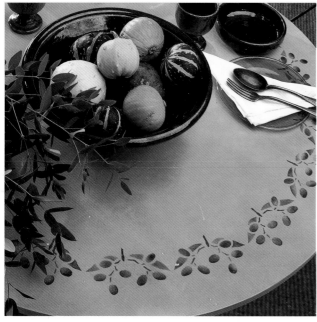

Tuscan Olives _____ 16

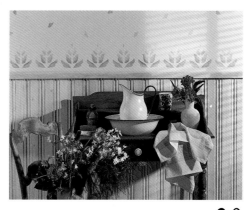

Scandinavian Flowers _____ 20

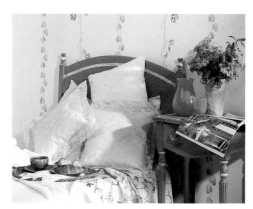

Morning Glory _____ 24

Autumn Hedgerow _____ 28

INTRODUCING STENCILLING

O nce you begin stencilling you will be amazed at the wonderful results you can obtain quite easily and without spending a great deal of money. This book introduces six themed projects and provides ready-to-use stencils that can be used with numerous variations in design – just follow the step-by-step features and simple instructions. With very little paint and only a few pieces of equipment you can achieve stunning results. Have fun!

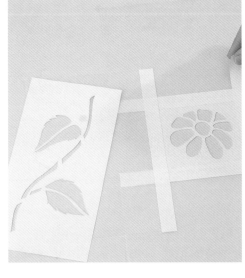

BASIC MATERIALS

Paints and Decorative Finishes
Emulsion paint
Water-based stencil paint
Oil sticks
Acrylic paints (bottles and tubes)
Specialist paints (for fabrics, ceramics, glass etc)
Spray paints
Metallic acrylic artists' colours (gold, silver etc)
Silver and gold art flow pens
Bronze powders (various metallics)
Gilt wax

Brushes and Applicators
Art brushes (variety of sizes)
Stencil brushes (small, medium and large)
Sponge applicators
Mini-roller and tray

Other Equipment
Set square
Blotting paper
Scissors or scalpel (or craft knife)
Roll of lining paper (for practising)
Eraser
Soft pencil
Fine-tip permanent pen
Chalk or Chalkline and powdered chalk
Long rigid ruler
Tape measure
Plumbline
Spirit level
Low-tack masking tape
Spray adhesive
Tracing paper
Paint dishes or palettes
Cloths
Kitchen roll
White spirit
Stencil plastic or card
Cotton buds
Methylated spirits

CUTTING OUT STENCILS
The stencils at the back of the book are all designed to use separately or together to create many different pattern combinations. Cut along the dotted lines of the individual stencils and make sure you transfer the reference code onto each one with a permanent pen. Carefully remove the cut-out pieces of the stencil. Apply 50 mm (2 in) strips of tracing paper around the edges using masking tape; this will help to prevent smudging paint onto your surface.

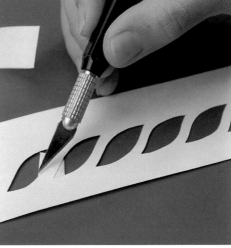

REPAIRING STENCILS
Stencils may become damaged and torn from mishandling, or if the cutouts have not been removed carefully, but they are easy to repair. Keeping the stencil perfectly flat, cover both sides of the tear with masking tape. Then carefully remove any excess tape with a scalpel.

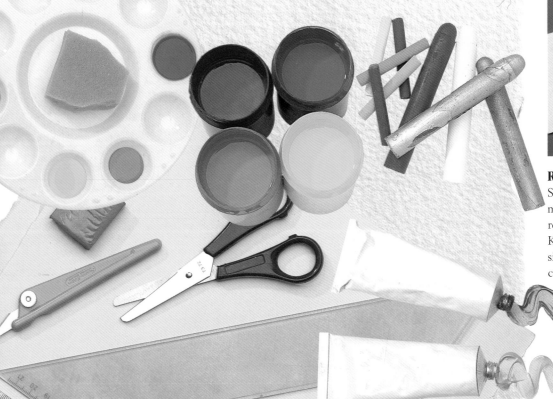

GETTING STARTED

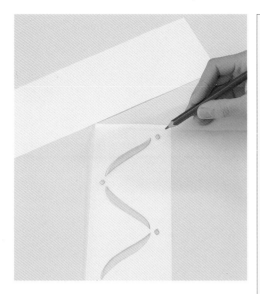

DUPLICATING STENCILS

Stencil plastic (Mylar) can be used; or card wiped over with linseed oil, which left to dry will harden and make the surface waterproof. Place the cut-out stencil on top. Trace around carefully with a permanent pen inside the cut-out shapes. Cut along the lines with a scalpel and remove the pieces. You may prefer to trace on top of the design, then transfer your tracing onto card.

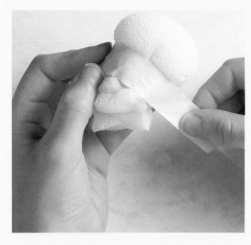

MAKING A SPONGE APPLICATOR

Sponging your stencil is one of the easiest methods, but you may prefer to use a stencil brush, especially for fine detail. Using a piece of upholstery foam or very dense bath sponge, cut pieces 12–50 mm ($^1/_2$–2 in) wide and approximately 50 mm (2 in) long. Hold the four corners together and secure with tape to form a pad. You can also round off the ends with scissors or a scalpel and trim to a smooth finish. The small-ended applicators can be used for tiny, intricate patterns.

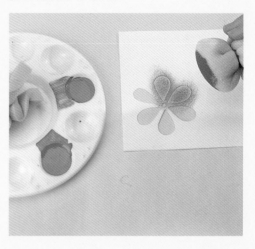

HOW TO USE WATER-BASED PAINT

Water-based paints are easy and economical to use and have the advantage of drying quickly. For professional-looking stencils, do not load your sponge or brush too heavily or you will not achieve a soft, shaded finish. Paint that is too watery will seep under the stencil edges and smudge. If the paint is too heavy you will obtain a heavy block effect rather than the soft stippling you require.

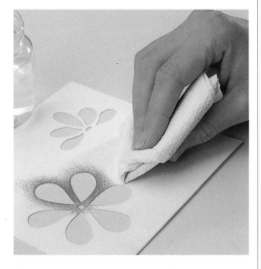

LOOKING AFTER STENCILS

Stencils have a long life if cared for correctly. Before cleaning make sure you remove any tape or tracing paper that has been added. Remove any excess paint before it dries, and wipe the stencil with a damp cloth every time you use it. If water or acrylic paint has dried and hardened, soften it with water and ease it off gently with a scalpel. Then use a small amount of methylated spirits on a cloth to remove the rest. An oil-based paint can simply be removed by wiping over the stencil with white spirit on a cloth. Stencils should be dried thoroughly before storing flat between sheets of greaseproof paper.

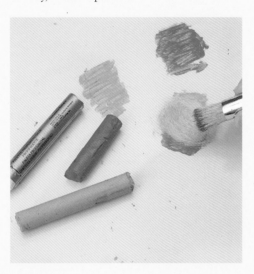

HOW TO USE OIL STICKS

Oil sticks may seem expensive, but in fact go a long way. They take longer to dry, allowing you to blend colours very effectively. Oil sticks are applied with a stencil brush and you need to have a different brush for each colour. Break the seal as instructed on the stick and rub a patch of the colour onto a palette, allowing space to blend colours. As the stencil sticks dry slowly, you need to lift the stencil off cleanly, and replace to continue the pattern.

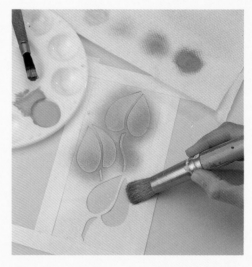

PRACTISING PAINTING STENCILS

Roll out some lining paper onto a table and select the stencil you wish to practise with. Using spray adhesive, lightly spray the back of your stencil and place it into position on the paper. Prepare your paint on a palette. Dab your sponge or brush into the paint and offload excess paint onto scrap paper. Apply colour over the stencil in a light coat to create an even stippled effect. You can always stencil on a little more paint if a stronger effect is needed, but if you over apply it in the first place it is very difficult to remove. Keep separate sponges for different colours.

PLANNING YOUR DESIGN

Before starting to stencil take time to plan your design. Decide where you want to use the patterns, then work out how to position the stencils so that the design will fit around obstacles such as doorways and corners. The techniques shown here will help you to undertake the job with a systematic approach.

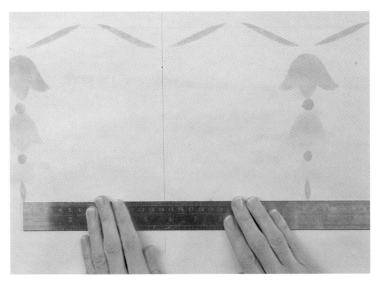
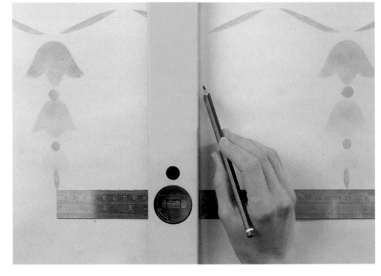

PUTTING PATTERN PIECES TOGETHER

1 Before you apply your design, stencil a sample onto lining paper. Mark the centre and baseline of the design on the paper and put together your pattern pieces. You can then work out the size of the design, how it will fit into the space available and the distance required between repeats.

2 You can avoid stencilling around a corner by working out the number of pattern repeats needed, and allowing extra space either between repeats or within the pattern. Creating vertical lines through the pattern will allow you to stretch it evenly.

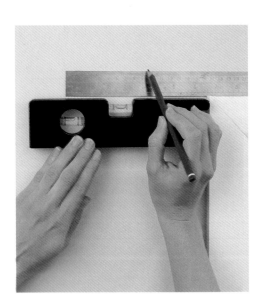
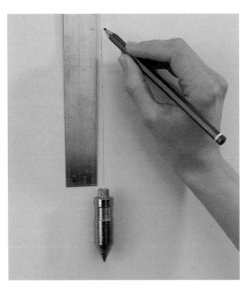
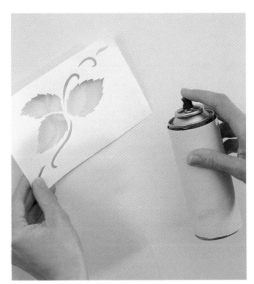

MARKING BASELINES AND HORIZONTAL LINES

Select your stencil area, and take a measure from the ceiling, doorframe, window or edging, bearing in mind the depth of your stencil. Using a spirit level, mark out a horizontal line. You can then extend this by using a chalkline or long ruler with chalk or soft pencil.

MARKING VERTICAL LINES

If you need to work out the vertical position for a stencil, hang a plumbline above the stencilling area and use a ruler to draw a vertical line with chalk or a soft pencil. You will need to use this method when creating an all-over wallpaper design.

FIXING THE STENCIL INTO PLACE

Lightly spray the back of the stencil with spray adhesive, then put it in position and smooth it down carefully. You can use low-tack masking tape if you prefer, but take care not to damage the surface to be stencilled; keep the whole stencil flat to prevent paint seeping underneath.

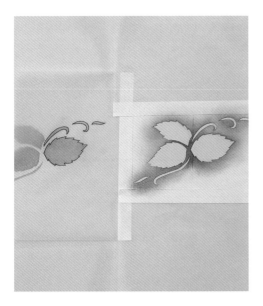

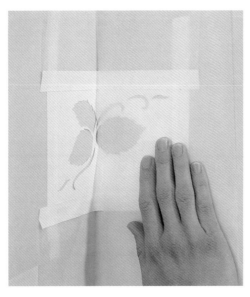

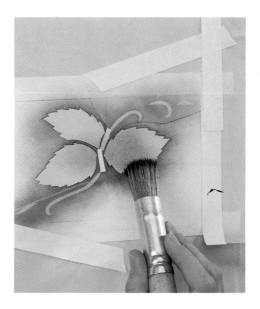

MARKING THE STENCIL FOR A PATTERN REPEAT

Attach a border of tracing paper to each edge of the stencil. Position the next pattern and overlap the tracing paper onto the previous design, tracing over the edge of it. By matching the tracing with the previous pattern as you work along you will be able to align and repeat the stencil at the same intervals.

COPING WITH CORNERS

Stencil around corners after you have finished the rest of the design, having measured to leave the correct space for the corner pattern before you do so. Then bend the stencil into the corner and mask off one side of it. Stencil the open side and allow the paint to dry, then mask off this half and stencil the other part to complete the design.

MASKING OFF PART OF A STENCIL

Use low-tack masking tape to mask out small or intricate areas of stencil. You can also use ordinary masking tape, but remove excess stickiness first by peeling it on and off your skin or a cloth once or twice. To block off inside shapes and large areas, cut out pieces of tracing paper to the appropriate size and fix them on top with spray adhesive.

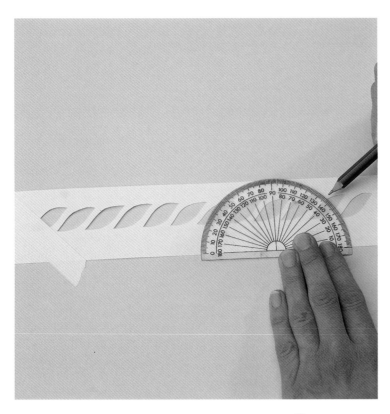

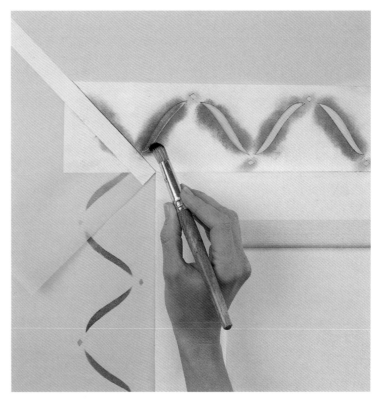

MITRING STENCIL PATTERNS

1 When you are stencilling a continuous pattern and need to make a corner, mask off the stencil by marking a 45-degree angle at both ends of the stencil with a permanent pen. Mask along this line with a piece of masking tape or tracing paper.

2 Make sure the baselines of the stencil on both sides of the corner are the same distance from the edge, and that they cross at the corner. Put the diagonal end of the stencil right into the corner and apply the paint. Turn the stencil sideways to align the other diagonal end of the stencil and turn the corner.

PAINT EFFECTS

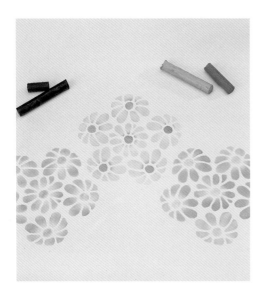

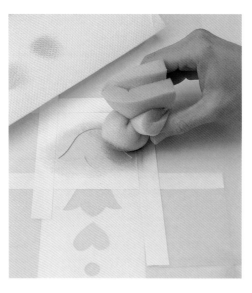

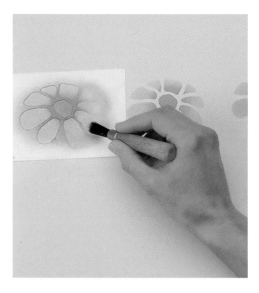

CHOOSING COLOURS

Take care to choose appropriate colours to create the effect you want. Stencil a practice piece onto paper and try a variation of colours to ensure you are pleased with the result. Different colours can make a design look entirely different. Use spray adhesive to fix your practice paper onto the surface on which you wish to produce the design so that you can assess its effect before applying the stencil.

APPLYING WATER-BASED COLOURS

Water-based paint dries quickly, so it tends to layer rather than blend. It is best applied by using a swirling movement or gently dabbing, depending on the finished effect you wish to create. Once you have applied a light base colour, you can add a darker edge for shading. Alternatively, leave some of the stencil bare and add a different tone to that area to obtain a shaded or highlighted appearance.

BLENDING OIL-STICK COLOURS

Oil sticks mix together smoothly and are perfect for blending colours. Place the colours separately on your palette and mix them with white to obtain a variety of tones or blend them together to create new colours. You can also blend by applying one coat into another with a stippling motion while stencilling. Blending looks most effective when applying a pale base coat, then shading on top with a darker colour.

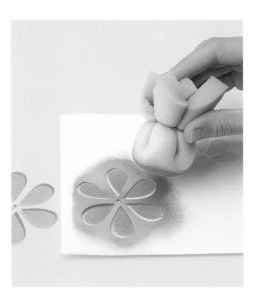

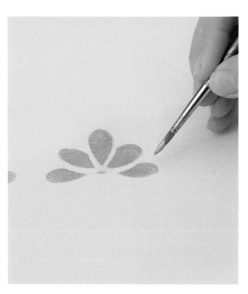

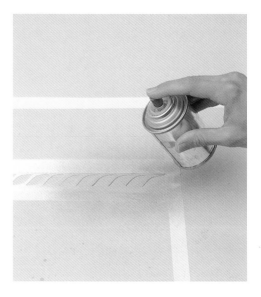

HIGHLIGHTING

A simple way to add highlighting to your design is first to paint in your stencil in a light tone of your main colour, then carefully lift the stencil and move it down a fraction. Then stencil in a darker shade; this leaves the highlighted areas around the top edges of the pattern.

GILDING

After painting your stencil use gold to highlight the edges. Load a fine art brush with gold acrylic paint and carefully outline the top edges of the pattern. Use one quick brush stroke for each pattern repeat, keeping in the same direction. Other methods are to blow bronze powder onto the wet paint, draw around the pattern with a gold flow pen, or smudge on gilt wax cream, then buff to a high sheen.

APPLYING SPRAY PAINTS

Spray paints are ideal on glass, wood, metal, plastic and ceramic surfaces. They are quick to apply and fast drying, but cannot be blended, although you can achieve subtle shaded effects. Apply the paint in several thin coats. Mask off a large area around the design to protect it from the spray, which tends to drift. Try to use sprays out of doors or in a well-ventilated area. Some spray paints are non-toxic, making them ideal for children's furniture.

DIFFERENT SURFACES

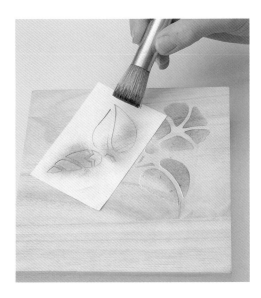

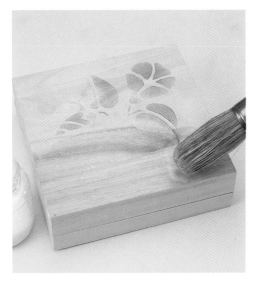

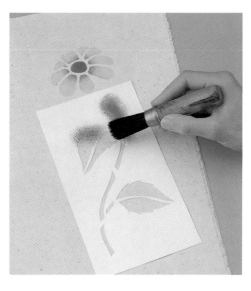

BARE WOOD

Rub the wood surface down to a smooth finish. Then fix the stencil in place and paint with a thin base coat of white, so that the stencil colours will stand out well when applied. Leave the stencil in place and allow to dry thoroughly, then apply your stencil colours in the normal way. When completely dry you can apply a coat of light wax or varnish to protect your stencil.

STAINED WOOD

If you are staining wood or medium-density fibreboard (MDF) prior to stencilling, you have a choice of many different wood shades as well as a wide range of colours. If the base coat is dark, stencil a thin coat of white paint on top. Apply your stencil and protect with a coat of clear varnish when it is completely dry.

FABRIC

Use special fabric paint for stencilling on fabric and follow the manufacturer's instructions carefully. Place card or blotting paper behind the fabric while working and keep the material taut. If you are painting a dark fabric, best results are achieved by stencilling first with white or a lighter shade. Heat seal the design following the manufacturer's instructions.

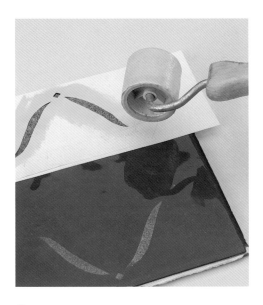

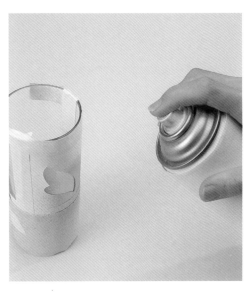

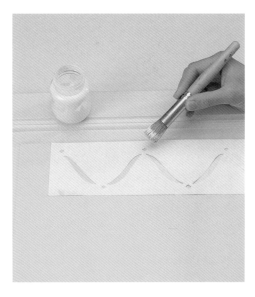

CERAMICS

Use special ceramic paints to work directly onto glazed ceramic tiles, and unglazed ceramics such as terracotta. Make sure all surfaces are clean, so that the stencils can be fixed easily. Apply the paint with a brush, sponge, spray or mini-roller. Ceramic paints are durable and washable, and full manufacturer's instructions are given on the container.

GLASS

Before applying the stencil make sure the glass is clean, spray on a light coat of adhesive and place the stencil in position. Spray on water-based or ceramic paint, remove the stencil and allow to dry. If you wish to stencil drinking glasses, use special non-toxic and water-resistant glass paints. An etched-glass look with stencils on windows, doors and mirrors can be achieved with a variety of materials.

PAINTED SURFACES

Stencils can be applied to surfaces painted with matt, satin or vinyl silk emulsion, oil scumble glazes, acrylic glazes and varnishes, and to matt wallpaper. If you wish to decorate a gloss surface, stencil first with an acrylic primer, leave to dry and then stencil the colours on top. Surfaces to be stencilled need to be smooth so that the stencil can lay flat.

INDIAN BLOOMS

Recreate the heat and mystery of the East with these Indian blooms. Flower and leaf designs are used extensively in Indian textiles and these stencils were inspired by fabrics from northern India. Traditionally such materials are produced in rich, bright colours, so I have used reds, pink and green with gold highlights to create a warm, exotic design for a room. The simplicity of the designs makes them versatile and the trailing ribbon is particularly suitable to use with other stencils in this book.

PAINT COLOUR GUIDE

Cream	Terracotta	Crimson red
Rust red	Rose red	Apple green
Gold (artists' acrylic)		

COLOURWASHING THE WALLS

1 Paint the walls with two coats of cream silk emulsion paint. Mix a glaze using terracotta paint and acrylic scumble and brush onto the wall, painting a small area at a time. Before the glaze dries wipe it through with a cloth to give a washed effect.

2 Plan the pattern using a square of card as a guide before painting the flowers as shown in the photograph below.

3 Paint the border using stencil A.

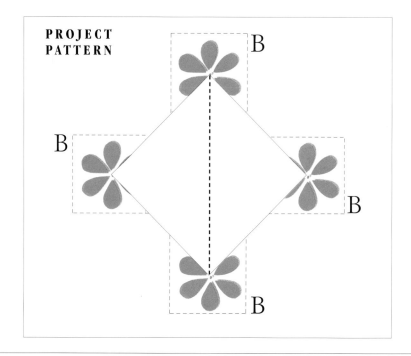

PROJECT PATTERN

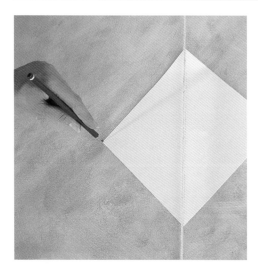

POSITIONING THE FLOWERS
Mark a vertical line. Cut a square of card and draw a line diagonally across it. Holding the card to the vertical, mark where the corners of the card touch the wall. These will be the flower positions. Mark the whole wall in this way as a guide for your pattern.

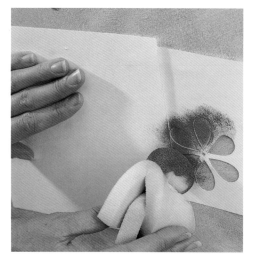

PAINTING THE FLOWERS
Load a sponge with crimson red, remove the excess paint on kitchen paper and paint some of the flowers using a dabbing action. Repeat with the other reds using a new sponge for each colour. Paint the centres of the flowers green or gold for contrast.

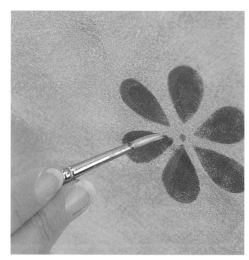

ADDING GOLD HIGHLIGHTS
Pour a little gold acrylic paint onto a saucer. Using an art brush, pick up some paint and apply it to the edges of the flowers to highlight them. Perfect your technique on paper.

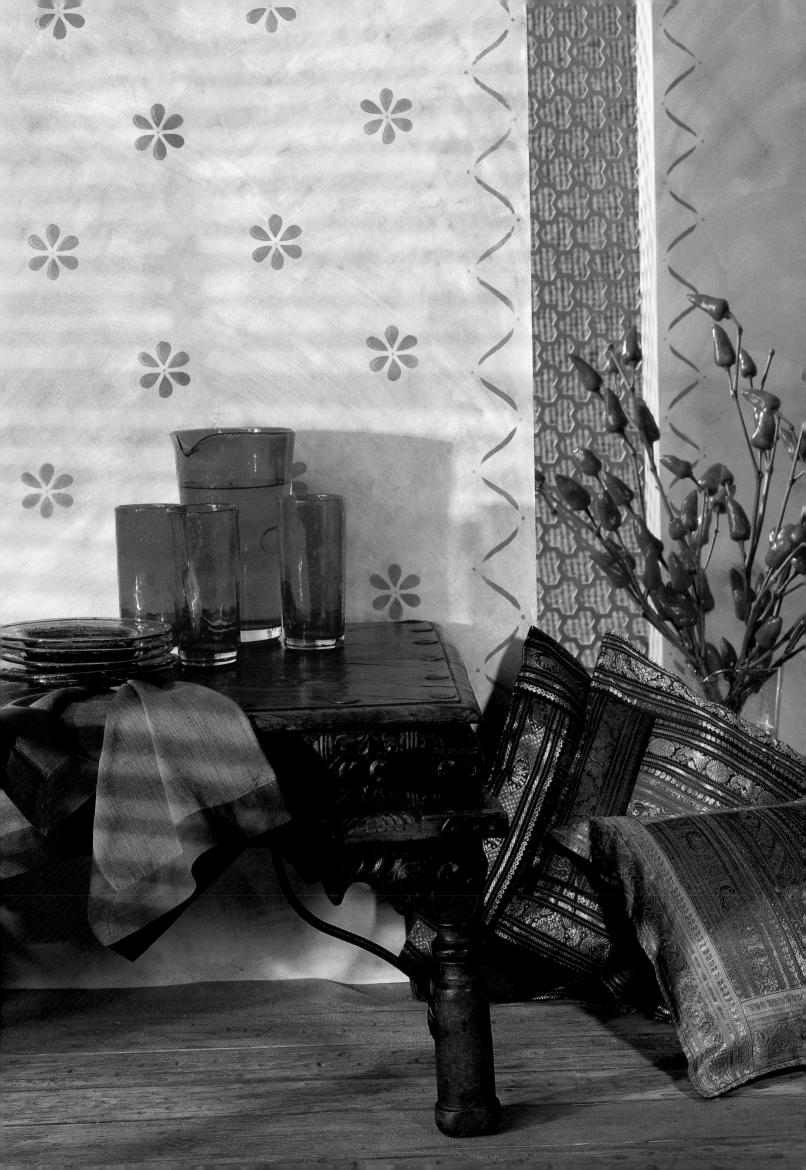

INDIAN BLOOMS VARIATIONS

These simple Indian Blooms stencils allow a great deal of flexibility when decorating – you can create borders, wallpapers and circular motifs. The variety of patterns shown here may inspire you to design many others. Experiment by combining the stencils and using different colours. Try rich jewel-like hues of deep blue and green, and add touches of gold to enhance particular areas.

HALF FLOWER AND RIBBON BORDER (STENCILS A AND B)

RIBBON EDGING (STENCIL A)

LEAF BORDER (STENCIL D)

LEAF ROSETTE BORDER (STENCIL D)

FLOWER AND LEAVES BORDER (STENCILS B AND C)

FLOWER BORDER (STENCIL B)

DOUBLE RIBBON BORDER (STENCIL A)

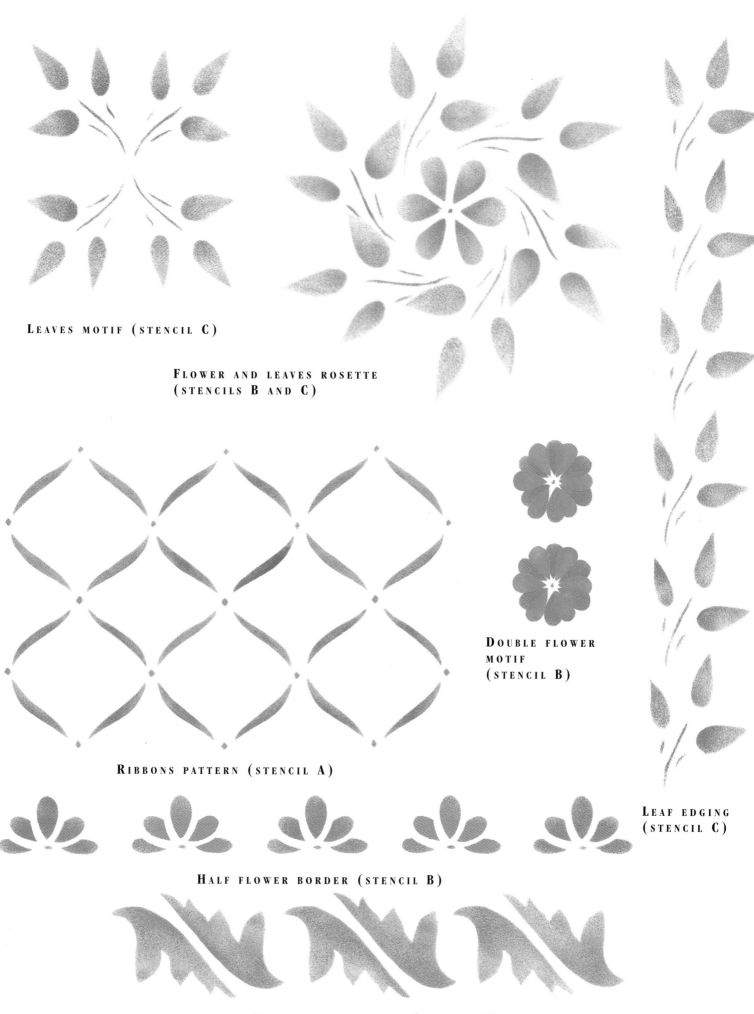

LEAVES MOTIF (STENCIL C)

FLOWER AND LEAVES ROSETTE (STENCILS B AND C)

DOUBLE FLOWER MOTIF (STENCIL B)

RIBBONS PATTERN (STENCIL A)

LEAF EDGING (STENCIL C)

HALF FLOWER BORDER (STENCIL B)

DOUBLE LEAF BORDER (STENCIL D)

PAINT COLOUR GUIDE

White Yellow Red

Green

STENCILLING ONTO FABRIC

1 Wash the fabric before painting to remove any finishes. Press well.

2 When stencilling on fabric be particularly careful to use as dry a brush as possible to avoid paint seeping under the stencil. Fabric paints are available in a more limited range of colours, so mix the yellow and red paints for further warm yellows and oranges.

3 Position stem stencils B and D first before placing the flowers and leaves.

4 Fix fabric paint according to the manufacturer's instructions.

SUNSHINE DAISIES

This sunny daisy design seems to represent all the warmth of summer. Stencilled onto table linen these flowers will brighten any meal and bring glowing compliments from guests. Placemats could be stencilled to match the tablecloth. Stencilling onto fabric requires confidence as mistakes cannot be wiped away, but with a little practice this project is well within the reach of a beginner.

The table linen here has been painted in warm yellows, but the flowers would look equally striking in other bright colours.

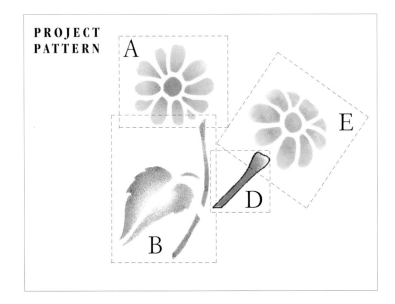

PROJECT PATTERN

A

E

D

B

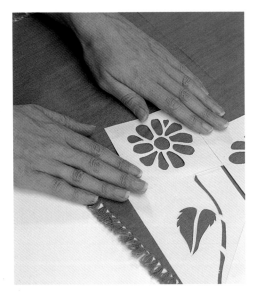

POSITIONING THE STENCIL
Use parts of the stem (stencil B) and flower stencils to make a bunch, masking areas not to be painted. Hold the stencil in place on the fabric with spray adhesive. Reposition the stencils carefully for each subsequent colour you apply.

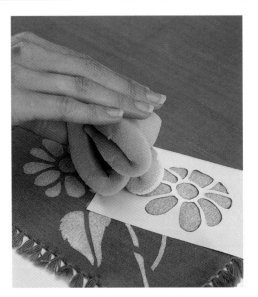

PAINTING THE STENCIL
When working on a coloured fabric, paint the whole design in white before applying the colours. Allow the white paint to dry and fix according to the manufacturer's instructions before adding the colours. This gives a good background for the subsequent colours.

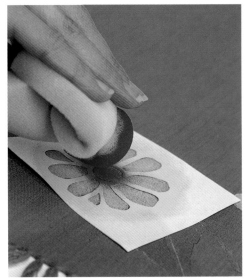

ADDING THE COLOURS
Use a clean sponge to apply pale yellow for the petals. Let the yellow paint dry and fix it before adding more colours. Paint a rich orange-red in the centre for the stamens. Overlap the colours to effect a gradual change.

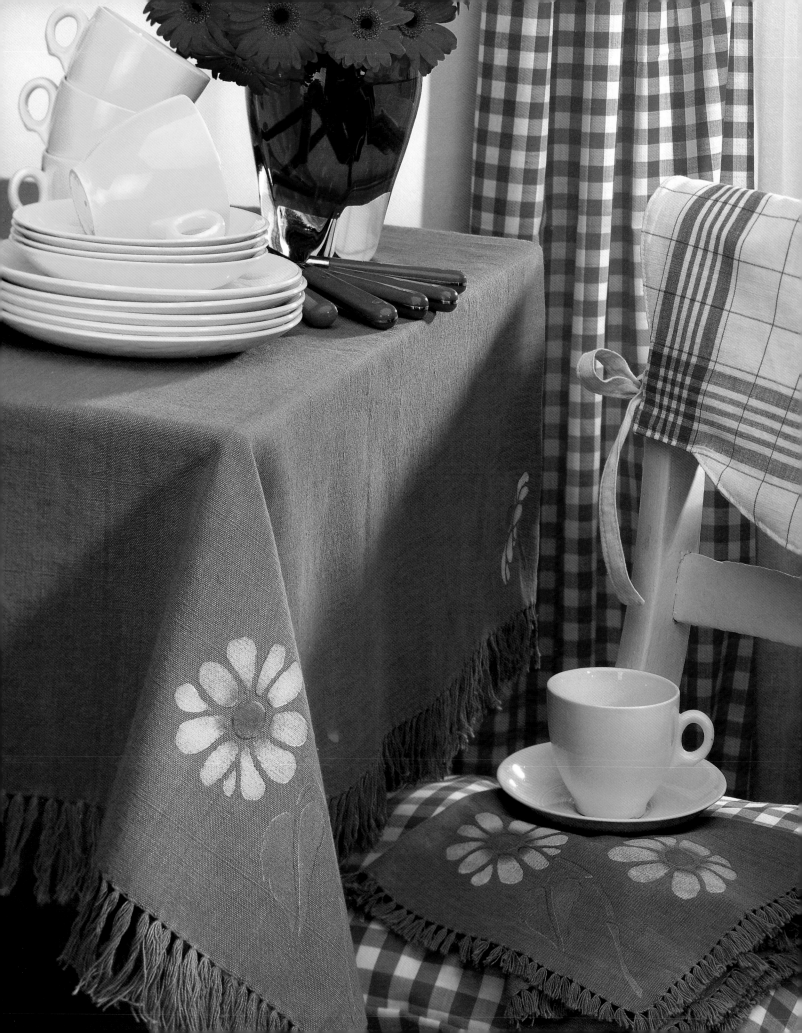

The Sunshine Daisies stencils look good on walls and furniture as well as on fabric. Paint a border of flower heads in the breakfast room to complement your tablecloth. The circle of leaves is formed by overlapping a leaf stencil, taking care not to paint over the previous leaf. Try painting the flowers in different colours and flipping the stencils to create a posy.

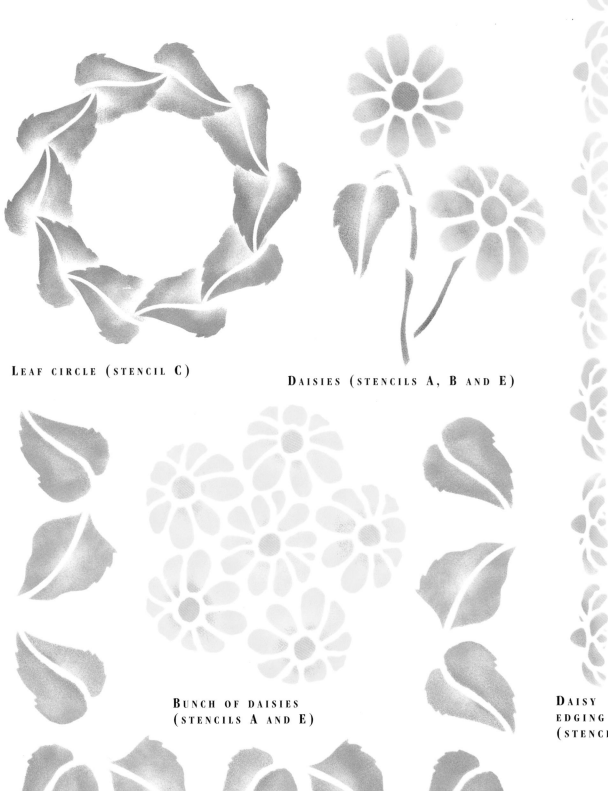

LEAF CIRCLE (STENCIL C)

DAISIES (STENCILS A, B AND E)

BUNCH OF DAISIES
(STENCILS A AND E)

DAISY
EDGING
(STENCIL D)

LEAF BORDER (STENCIL C)

DAISY AND LEAF
BORDER (STENCILS
A AND B)

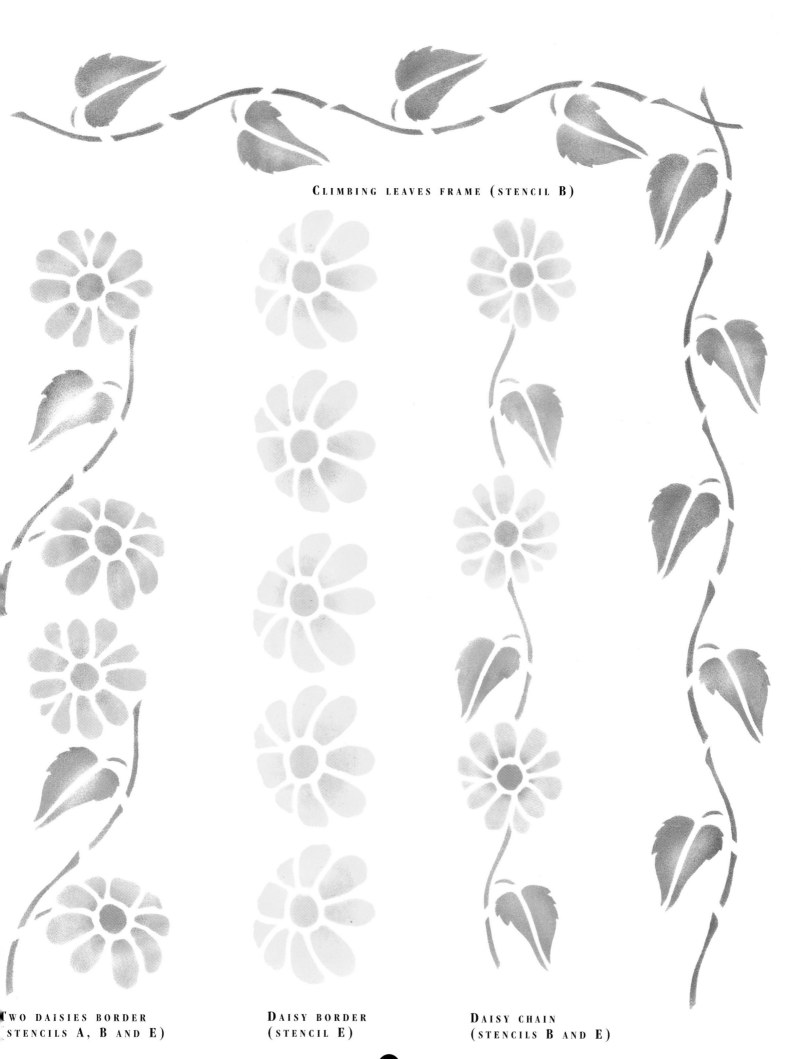

CLIMBING LEAVES FRAME (STENCIL B)

TWO DAISIES BORDER
(STENCILS A, B AND E)

DAISY BORDER
(STENCIL E)

DAISY CHAIN
(STENCILS B AND E)

TUSCAN OLIVES

Enjoy long summer evenings over a meal around this patio table. Stencilled with plump Mediterranean olives, it brings the flavour and atmosphere of Tuscany to your own home. The table is painted in traditional Tuscan earth colours that are rich and warm, and provide an authentic-looking background for the border of olives. It has been finished with an antiquing varnish that enhances the colours and give it an aged look. A final coat of clear varnish protects the surface.

PAINT COLOUR GUIDE

Mustard yellow Terracotta Olive green

Yellow-green Dark green Brown

Black

PREPARING AND FINISHING THE TABLE

1 Paint the table with two coats of mustard yellow emulsion paint. Make a glaze using acrylic scumble and terracotta paint. Using a soft cloth, pick up some glaze and rub it over the table top to give it a textured finish. The base colour should now show through the glaze. After stencilling, apply antiquing varnish.

2 Plan the positions of the stencilling by measuring carefully. Design a one-eighth segment around the table to check the fit.

PROJECT PATTERN

A

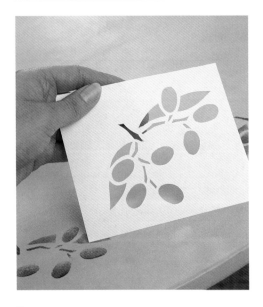

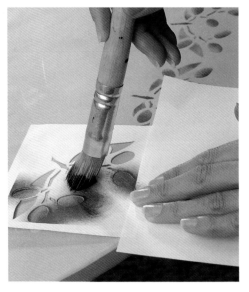

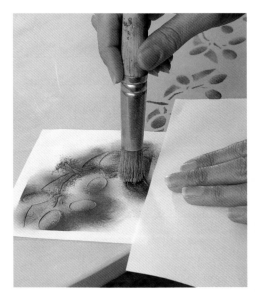

POSITIONING THE OLIVE STENCIL
Plan the positions of your stencils around the edge of the table top. Careful measuring at the start will ensure that you are not left with either too much or too little space to complete the circle. First work out how a one-eighth segment will look.

PAINTING THE OLIVES
Use a different brush for each colour. Load the tip of the brush, removing excess paint on kitchen paper. Apply the paint by tapping or 'pouncing' or, for a smoother look, press lightly on the bristles and use a circular motion.

SHADING
Solid blocks of colour will appear flat and heavy, so highlight one side of each olive with lighter green paint, making the olives appear round. Use two greens on the leaves to give a more realistic effect.

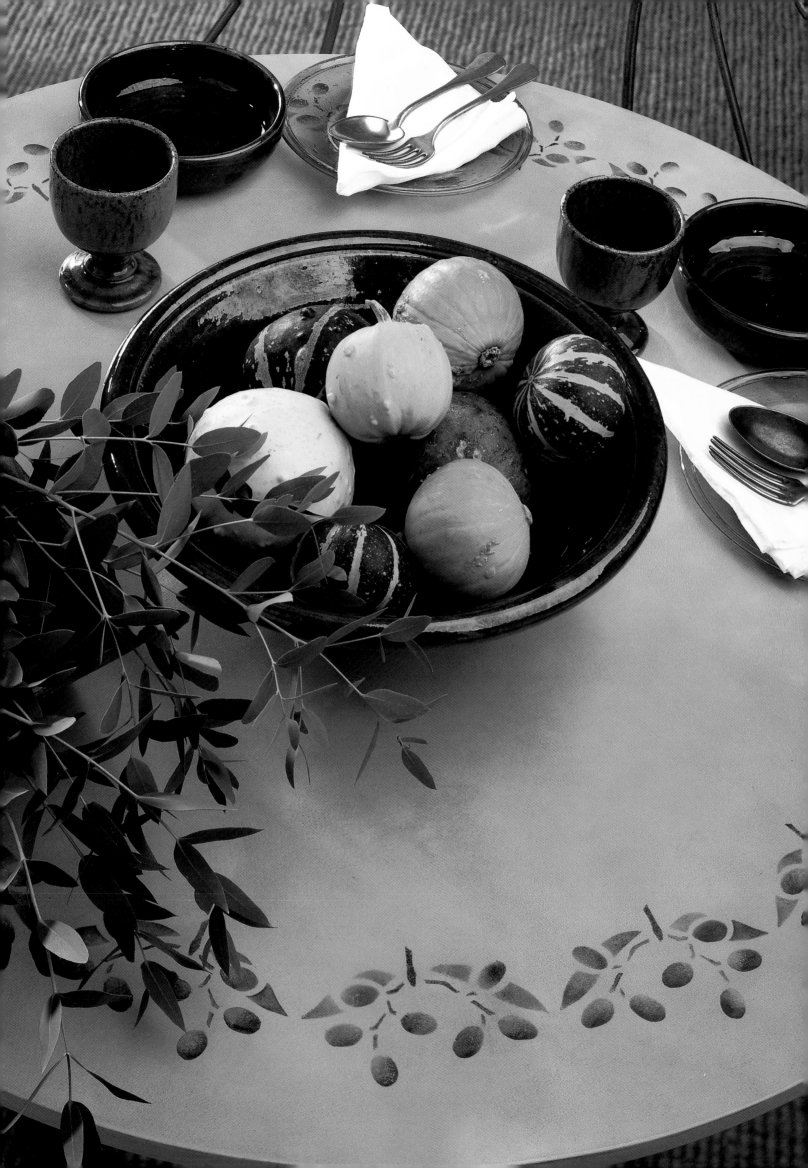

TUSCAN OLIVES VARIATIONS

Use a single stencil to make a repeating border or combine parts of the designs for a geometric all-over pattern. To make a square tile design, paint the line stencil as a frame using the ends as a link. Position the leaf stencils inside some of the squares. The variations illustrated here show how the use of colour can give quite different effects.

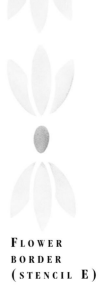

LEAF SPRAY (STENCIL F)

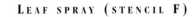

CIRCLE OF OLIVES (STENCIL A)

FLOWER BORDER (STENCIL E)

FLOWER BORDER (STENCIL E)

LEAVES EDGING (STENCIL F)

FLOWER AND BROKEN LINE BORDER (STENCILS D AND E)

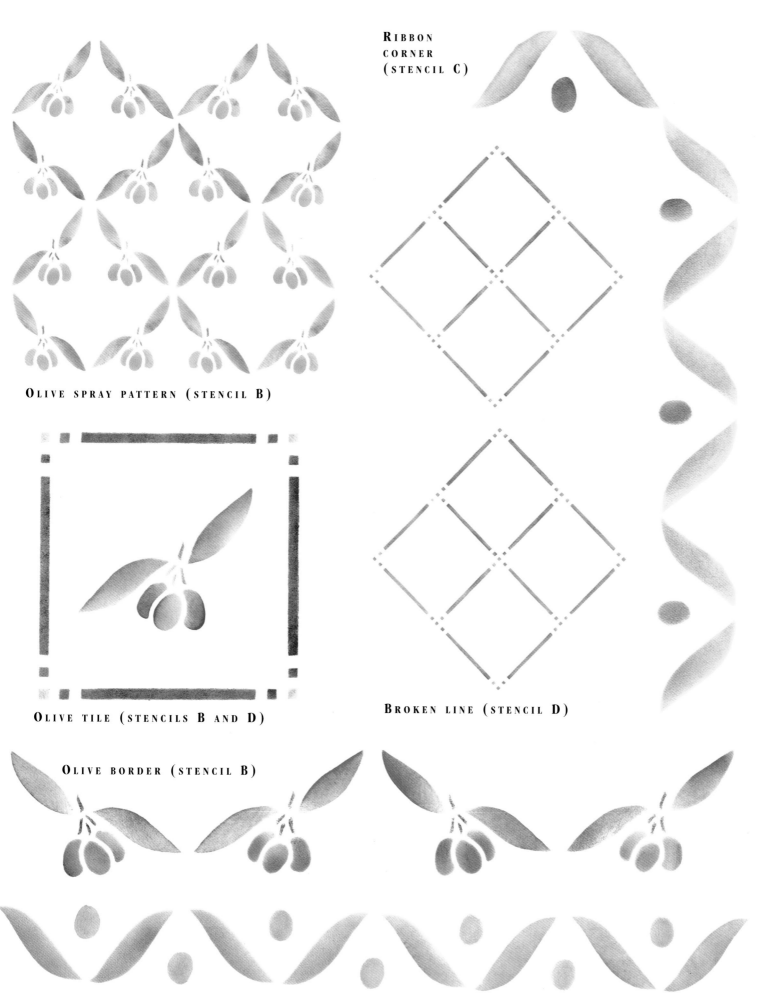

RIBBON
CORNER
(STENCIL C)

OLIVE SPRAY PATTERN (STENCIL B)

OLIVE TILE (STENCILS B AND D)

BROKEN LINE (STENCIL D)

OLIVE BORDER (STENCIL B)

OLIVE RIBBON BORDER (STENCIL C)

SCANDINAVIAN FLOWERS

These Scandinavian-style stencils were inspired by the architectural detail on a 19th-century Swedish house decorated in the Gustavian style. Their charm lies in their simplicity and the wonderful muted colours of the traditional Scandinavian palette. Soft grey-greens and blues combine to make this a very restful room. The border has been created by combining the leaf stencils and the wall is covered with individual tumbling leaves. To create a completely different look try painting these stencils in strong bright colours.

PAINT COLOUR GUIDE

Cream	Deep blue-green	Mid blue-green
Pale blue-green		Blue-grey

PLANNING A BORDER

1 Carefully position the individual pieces to make a stylised border. The design here uses the three leaf stencils (C, D and E) and part of the hanging bells stencil (F).

2 Draw the design on a sheet of paper before you begin and note how the pieces are arranged. This will make it much easier when you come to put them on the wall.

3 Measure the distance to be covered carefully so that the pattern will fit, working each part of the design from its centre.

PROJECT PATTERN

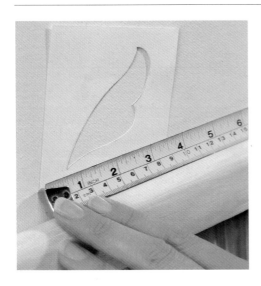

POSITIONING THE STENCIL
Mark the centre of the wall for the position of the first stencil. Measure the wall so that the design fits and you are not left without enough room to place a complete design. This will save you bending the stencils around a corner.

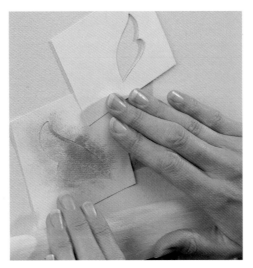

ALIGNING THE STENCILS
The complete design is formed by painting leaf stencil E, flipping it over and painting it again as a mirror image, and repeating the process with leaves D and C. This is topped with the drop shape from stencil F. Measure from a central vertical line.

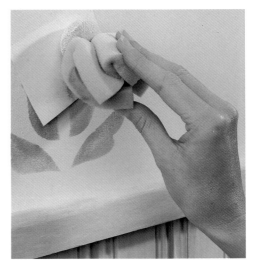

PAINTING
Use a sponge for each colour. Begin with the lowest leaf, painting in the order blue-grey, dark blue-green, mid blue-green and pale blue-green, blending from leaf to leaf. This gives weight and interest to the design.

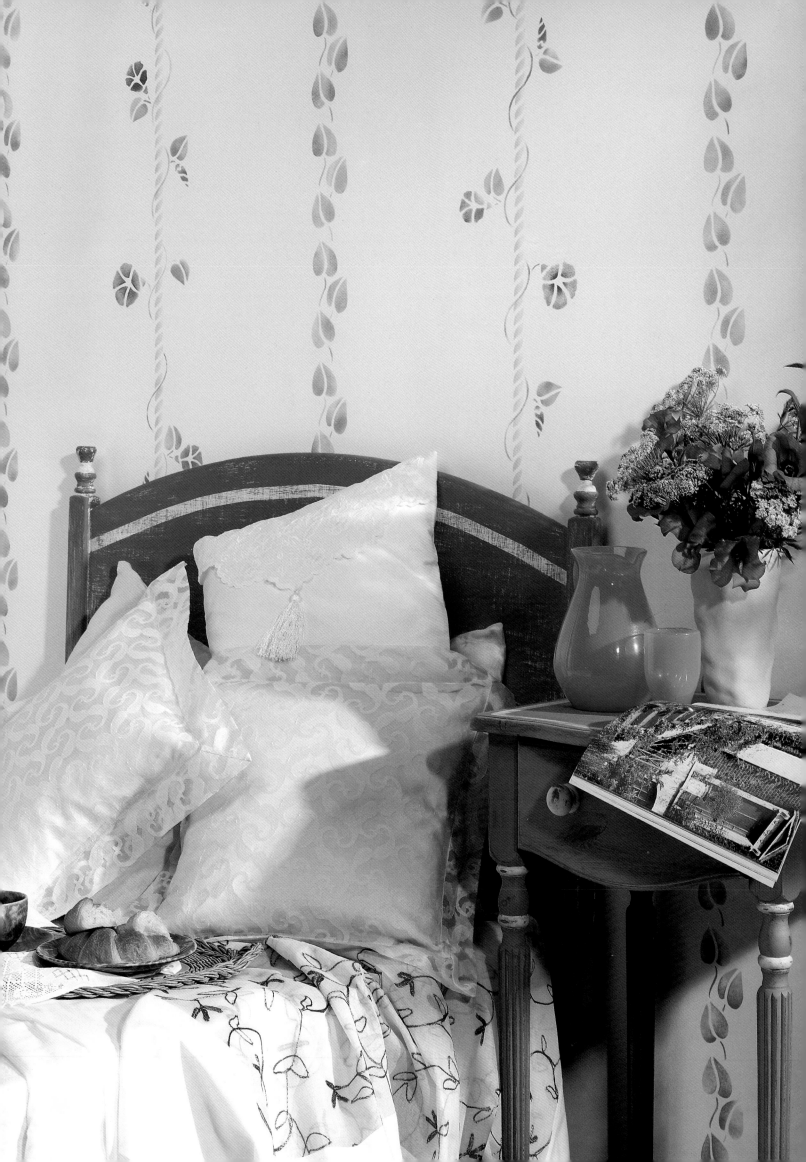

MORNING GLORY VARIATIONS

The flowers and leaves of the Morning Glory stencils can be used singly or combined in borders and motifs, and this design is particularly suited to trailing effects. The stem stencil can also be used on its own to make some very smart designs reminiscent of wrought-iron work. Mitre the ends of the rope to make a frame and paint some flowers in the centre.

LEAF AND FLOWER (STENCIL E)

ROPE EDGING (STENCIL A)

DOUBLE SCROLL BORDER (STENCIL F)

LEAVES BORDER (STENCIL B)

FLOWER AND BUD BORDER (STENCIL D)

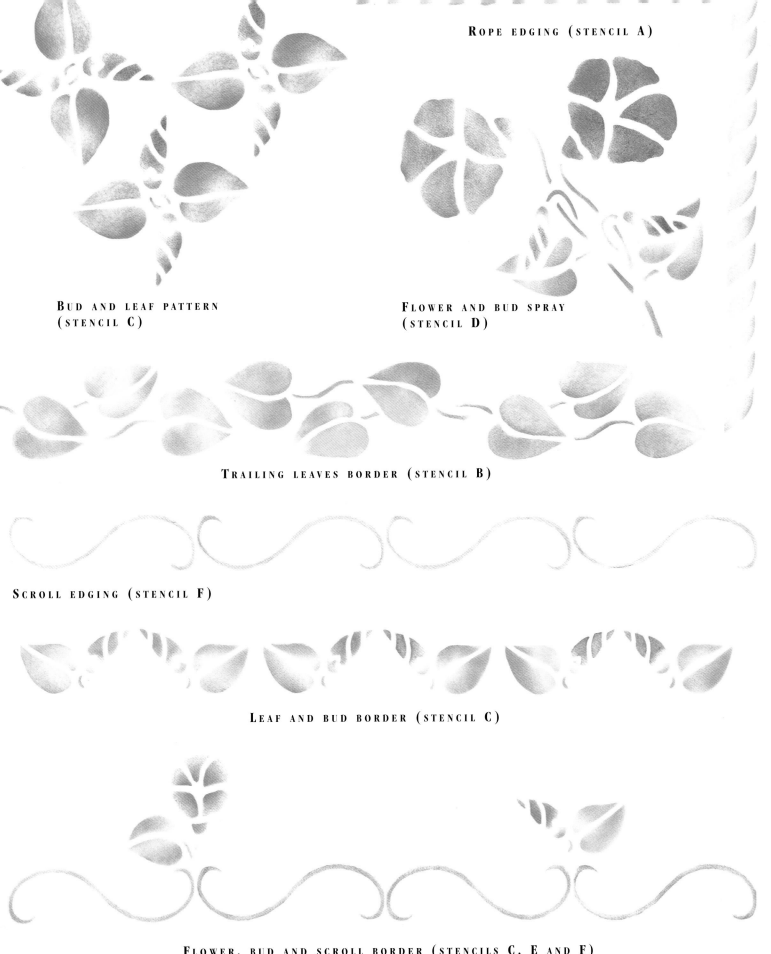

ROPE EDGING (STENCIL A)

BUD AND LEAF PATTERN
(STENCIL C)

FLOWER AND BUD SPRAY
(STENCIL D)

TRAILING LEAVES BORDER (STENCIL B)

SCROLL EDGING (STENCIL F)

LEAF AND BUD BORDER (STENCIL C)

FLOWER, BUD AND SCROLL BORDER (STENCILS C, E AND F)

PAINT COLOUR GUIDE

Yellow ochre	Plum	Bright red
Fresh green	Warm yellow	

ARRANGING THE STENCILS

1 Arranging these stencils requires a little practice. Start by painting one stencil, perhaps some leaves. Then hold another of the designs to it to decide which section to paint next; choose all or part of a design, whichever looks right in that position.

2 Continue building up your design in this way. The patterns can be made to curve around an arch, make a border or trail round a corner.

Capture the richness of autumn with these hedgerow stencils of rich juicy black berries, ripe rosehips and leaves changing colour from green to russet. This archway decorated with fruit and leaves trailing haphazardly around its frame perfectly evokes the season of 'mists and mellow fruitfulness'. The stencils are ideal for making matching, but not identical, designs in other areas of the room. Use random combinations of patterns to paint a border or highlight another feature, such as a window.

PROJECT PATTERN

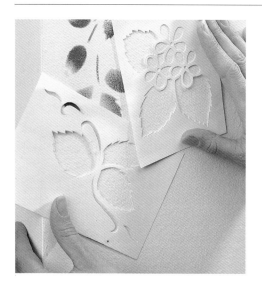

POSITIONING THE STENCILS
Position these stencils individually to curve around the archway. A random arrangement will look more natural than a repetition of the same designs. Start with one of the stencils, adding all or parts of the other designs to form a pleasing arrangement.

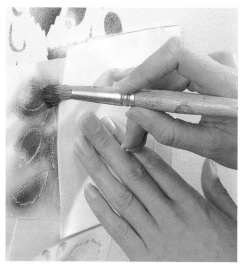

PAINTING THE STENCIL
Paint the blackberries (stencil B) with the plum paint and the rosehips (stencil E) with bright red. Use yellow and green for the flowers and leaves. Blend and shade colours to enhance the effect. A touch of red on the edge of a leaf works well.

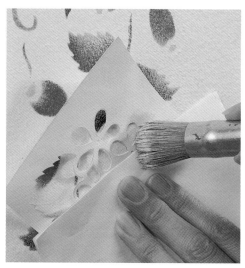

EXTRA DETAILS
Use parts of the stencil to add extra details and balance the design. A single flower or fruit may be all that is needed. Mask off areas of the stencil that you are not using.

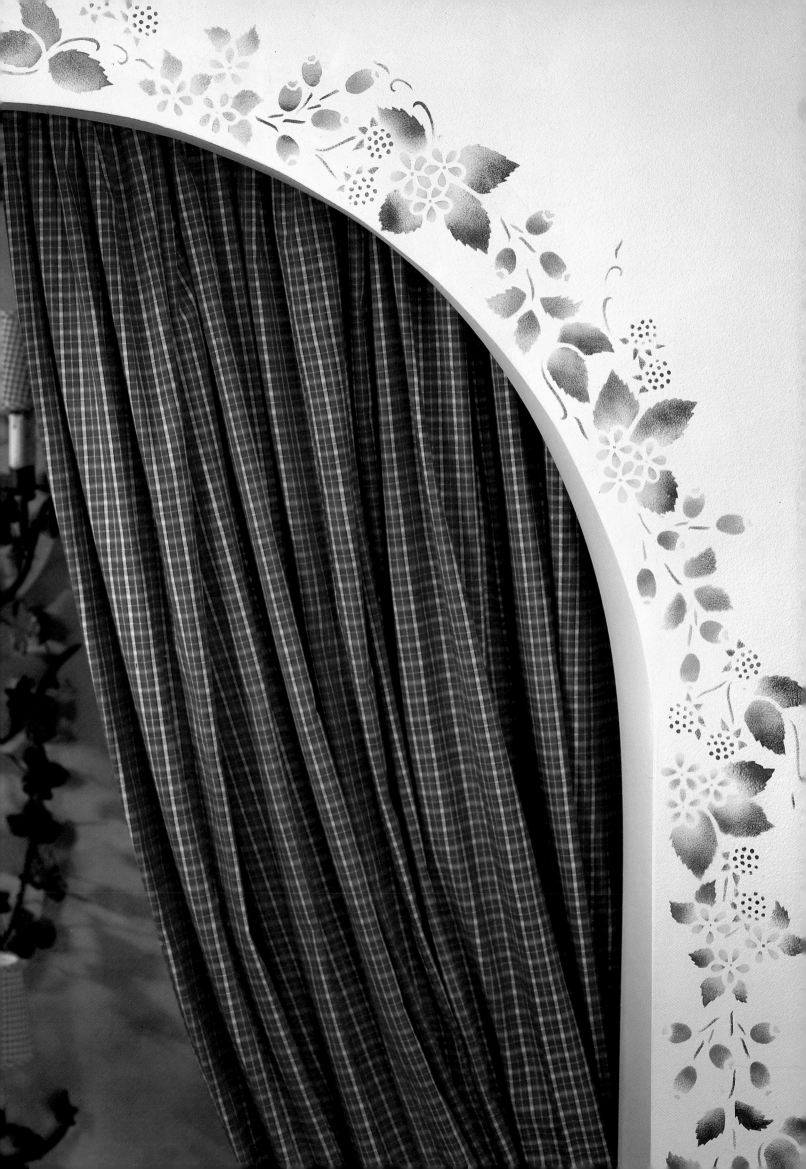

AUTUMN HEDGEROW VARIATIONS

The look of the hedgerow stencils can be changed by masking some details and combining the leaves from one stencil with the flowers from another. Or choose a single simple motif and repeat it, as shown in the blackberry border. The 'triangular' rosehip cluster has one rosehip omitted so that it fits neatly together. Vary the intensity of the colours you use, experiment and find your own style.

FLOWER CIRCLET (STENCIL C)

FLOWER BORDER (STENCIL C)

ROSEHIP DROP (STENCIL E)

FLOWER BORDER (STENCILS A AND D)

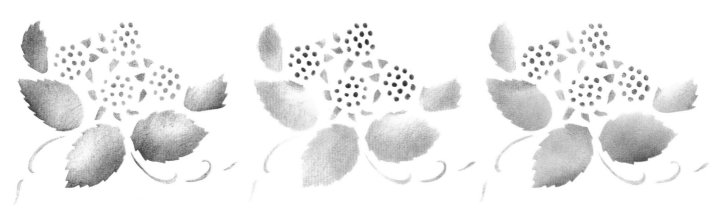

BLACKBERRIES AND LEAVES (STENCILS B, D AND E)

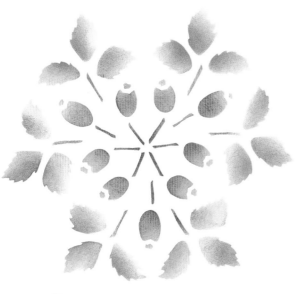

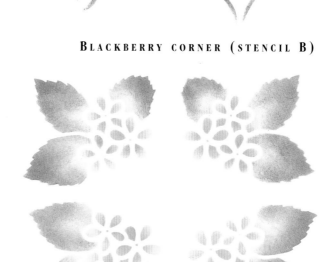

BLACKBERRY CORNER (STENCIL B)

**ROSEHIP CLUSTER
(STENCIL E)**

**RIGHT: FLOWER SQUARE
(STENCIL A)**

TRAILING LEAVES BORDER (STENCIL D)

BLACKBERRY EDGING (STENCIL B)

ROSHIP BORDER (STENCIL E)

SUPPLIERS

Fired Earth plc
Twyford Mill
Oxford Road
Adderbury
Oxfordshire
(Tel. 01295 812088)

Dulux Paints
ICI plc
Wexham Road
Slough
Berkshire
(Tel. 01753 550000)

ACKNOWLEDGEMENTS

Merehurst Limited wish to thank the following for their help: The Housemade; Cologne & Cotton; Thailandia; Josephine Ryan Antiques; Cath Kidston Ltd; Damask; Indigo.

First published in 1997 by Merehurst Limited
Ferry House, 51–57 Lacy Road, Putney, London SW15 1PR

ISBN 1-85391-691-9

A catalogue record of this book is available from the British Library.

Edited by Geraldine Christy
Photography by Graeme Ainscough
Styling by Clare Louise Hunt

Colour separation by Bright Arts (HK) Limited
Printed in Singapore

Denise Westcott Taylor teaches stencilling and paint effects courses as well as taking on private commisions. She is also currently teaching a City and Guilds course on working designs for creative studies.